When Light Falls from the Sun

ALLAN SAFARIK

Artworks by Terry Fenton

HAGIOS
PRESS

Library and Archives Canada Cataloguing in Publication

Safarik, Allan, 1948–
 When light falls from the sun / Allan Safarik ; art works by Terry Fenton.

Poems.
ISBN 0-9735567-7-3

 1. Saskatchewan – Poetry. I. Fenton, Terry, 1940– II. Title.
PS8587.A245W48 2005 C811'.54 C2005-904936-7

Edited by Paul Wilson.
Designed and typeset by Donald Ward.
Cover design by Yves Noblet.
Cover art: *L'Heure Exquise*, by Terry Fenton; photograph by Bill Faulkner.
Interior photography by Zach Hauser.
Text pages set in Slimbach and printed on 100 per cent post-consumer recycled paper. Printed and bound in Canada.

The publishers gratefully acknowledge the assistance of the Saskatchewan Arts Board, The Canada Council for the Arts, and the Cultural Industries Development Fund (Saskatchewan Department of Culture, Youth & Recreation) in the production of this book.

HAGIOS PRESS
Box 33024 Cathedral PO
Regina SK S4T 7X2

In memory of Anne Szumigalski
and Smith Atimoyoo

CONTENTS

Author's Preface 7
Artist's Preface 9

When Light Falls

The Thought of Finding 12
In First Light the Night Dies 13
June 14
The Garden at the End of July 15
Under the Blooded Flowers 16
Notes to Growing Cabbages 17
Night Light 18
Magpie Song 19
Dinners 21
The Trick of Silverware 22
Feline 23
Standing on the Edge of the Storm 24
A Simple Thought in Darkness 25
On the Twenty-Mile Bend 26
Evolution in Summer Time 27
Summer Storm Clouds 28
Night Garden 29
The Lizard Called Love 30
Window into Darkness 31
The Church Beside the Road 32
The Snake of Two Minds 33
The Hole in God's Shoe 34
Crossroads 35
The Eyes of Darkness 36

Heat Wave

Two Years Without Rain 38
The Waiting Game 39
Dry Places 40
Heat Wave 41
Blue Words 42

The Fire 43
Sand Hills 44
Weather Vane 45
When Light Falls from the Sun 47
Yellow Flower 48
News 49
Waltzing Man 50
Syllogism 51
Green Tomatoes 52
Shadow Land 53
Meditation on a Bird's Skull 54

"Time, Distance, Light, and Space"

Recent Works by Terry Fenton 55

Thirty Below

The Road To St. Denis 66
The Dugout 67
What Is Known about Regina 68
The Monkey Walks Softly on the Snow 69
The Pond as a Whetstone 70
Fat Cricket Dancing in the Fat 71
Silence 73
By Indi Lake 74
Miracle 75
Underwear Man 76
Winter Kill 77
Bug Dance 78
White Leghorns at Christmas 79
Snow Fills in the Landscape 80
Thirty Below 81
Prairie Haiku 82
Winter Moon 83
Impractical Days of Open Horizon 84
Last Exit to Assiniboia 85

Advice to a Young Dog 87
Four Meditations on La Loche 88
Bear on the Sofa 89
Elk Teeth 90
Wolf 92

Sound of Time

If You Dare Break this Silence 94
Choke Cherries 95
Ancients 96
Gopher Days 97
Hawk Soars Above 98
Dog Tail 99
Morning Comes a Day Later 101
The Presence 102
Death You Say Is on Your Mind 104
The Feathered Lure 105
Sound of Time 106
The Membership of the Open Road 107
Boot Hill 110

The most remarkable thing about living on the northern central plains is the astonishing relationship between the sky, the landscape, and the light. There is nothing more bracing than a clear bright sunlit forty below day in the middle of winter — when the light seems ethereal in its brilliance against the whiteness. Terry Fenton's paintings are works about light; or about its absence. He paints the sky and the simple earth below in the rapture of the light as it passes through the seasons and the weather. He has been painting on the back roads and the countryside immediately around the region where I live and travel while thinking about the poems that I habitually turn into books. We have been covering the same ground south of Saskatoon, only recording it in different media — mine, words on paper; his, oil paint on paper. When I look at his paintings I feel a powerful attraction — they understand the essence of this place in time, distance, light, and space. I marvel at the sunset painting, *L'Heure Exquise*, on the cover. It is a variation of a scene I witness many times each year on the back road five miles west of Dundurn when we go out in the evenings looking for deer. The sudden sensation of light having recently left the foreground is strangely disturbing as change quickly alters the balance and the moment is transformed into an astonishing abstraction. Fenton's works are pure and persistent in portraying the powerful force of light on a subtle landscape. They invoke memory and let me see the light again in ways that inspire me to think about ideas and how they might be best illuminated in the countryside of the imagination.

A handful of these poems, including "Yellow Flower" and "Green Tomatoes," first appeared in the final editions of *Western People*. "Summer Storm Clouds" and "Impractical Days of Open Horizon" were first published in a Canadian issue of *River King Poetry Supplement* edited by Glen Sorestad. "In First Light the Night Dies" was published in *Prairie Journal*, "The Pond As A Whetstone" in *The Fiddlehead*, "Sound Of Time" in *The Society*, and "Weather Vane" in *Prairie Poetry*. A version of "Membership

of the Open Road" was performed live at the CBC Atrium in Regina, accompanied by Lee Kozak on guitar, recorded and broadcast on CBC Radio's *Poetry Canada Face-Off 2004*. "The Monkey Walks Softly on the Snow" was produced by Kelley Jo Burke and broadcast on CBC *Gallery*, 2005. "Choke Cherries" and "Wolf" first appeared in *All Night Highway* (Black Moss), while "Magpie Song," "White Leghorns at Christmas," "The Fire," "Sand Hills," "Meditations on a Bird's Skull," and "Dog Tail" appeared in my selected bird poems, *Bird Writer's Handbook* (Exile). I have included them here because, while they were necessary birds, they were written for this collection.

Thanks to the Saskatchewan Arts Board for funding a year long writer-in-residency in Estevan in 2002, and for a grant in the spring of 2003 that allowed me freedom to write without interruption. In appreciation to Dolores Reimer for the continuous dialogue about the text, and to Jake, Emily, and Hank for understanding about the eccentricities of the writing life. And to my friend, Jeff Kusalik, for many amusing conversations.

Books are a collaborative effort: with thanks to Paul Wilson for his editing skills, to Don Ward for his typography, to Yves Noblet for the cover design, and to Terry Fenton for his artworks.

— Allan Safarik
Dundurn, July 2005

ARTIST'S PREFACE

The wide-open spaces of Saskatchewan seem the antithesis of what we think of as "scenery." They're not hemmed in by trees and interrupted by "views." They're not picturesque; they're everywhere all at once. And I love them.

The prairies are the only big part of Canada that the Group of Seven didn't paint. Their avoidance was deliberate. "Bury me not on the lone prairie," mourned A. Y. Jackson after being stranded amidst them briefly, "I could do nothing with the place."

Because of their spareness and apparent absence of scenery, the open prairies have seldom been painted by anyone else. Even painters who've flourished in Saskatchewan have gravitated to the river valleys in the plains or the aspen parkland to the north and east. While I admire and have absorbed much from several of those artists, I'm drawn, myself, south and west to the grasslands — partly out of familiarity (I was born and raised in Regina), but also because the colour and light there is so luminous. And because the solutions found by painters from the past aren't suited to the wide-open spaces, I look for new ones.

<div align="right">

— Terry Fenton
Saskatoon, July 2005

</div>

When Light Falls

THE THOUGHT OF FINDING

In the field, earth turned
under the sky in deep furrows
lines on faces ease into the future
this is how you will appear
when the time comes to depart
into the invisible atmosphere
I will shake a handful of dirt

grab the intangible smoke
cloaked in elusiveness going up
the crematorium chimney
shadows of slow-moving clouds
pass across burnished grasslands
I thought I would try again to tell you
only words are left between us

IN FIRST LIGHT THE NIGHT DIES

for Emily

Light comes as it does filtering down
through the trees like opportunity
in the green unmanaged wilderness
stars fade back into blueness
the colour of my daughter's eyes

Many strange gods live in the forest
sometimes on the edge of the ancient
town we hear hysterical laughter
catch a glimpse of the unknown or find
a secret trail through chest-high grass

Dogs find them hiding in the brush
and bark until the cows move away
swishing their tails at furious insects
already climbing the sun-warmed air
dizzy in their lust for bloody hosts

JUNE

In the mind of indelible memories
the insect hum in the still afternoon
occupies the background
An orchestration of elastic bands

A few cabbage butterflies
mimicking left-over snowflakes
around the breathless wind
lie shattered on cold ground

Ladybug on a leaf tries
out her untested wings
one spot of blood beneath
the skin of thin existence

An aggressive wasp gang
dance around menacing the air
pose like gunmen in the old west
hovering in a doorway

Refusing to give in to bullying
I slap with my empty hand
waiting for the gunshot of silence
to articulate the flat land

Do you think I hum in the mind
of an impressionable creature
in the still afternoon
dreaming in coloured ink?

THE GARDEN AT THE END OF JULY

Scarlet runner beans climb higher
than the scrubby poles holding them
above recumbent cucumber leaves
and pumpkin blossoms
I rip my bare foot on a rusty nail
protruding from a fence board
Before the blood clots on black earth
I leave a trail of drops like berries
marking the varied greenery

While I pluck the wild portulaca
the neighbour climbs over the fence
and begins to tell me his life story
The unadulterated sadness of it
reminds me of the time the minister
came to stay for four days to escape
her alienated congregation's wrath
After she finished talking
we never heard from her again

Before he got far in his melodrama
I offered to give him her phone number
but he said, there was no reason
to bring God into these issues
I figured he was wrong about that
a plague of red helmet-shaped bugs
appeared on the potato plants
the onions were nearly all done in
by stinking root maggots

Later that night drinking coffee
on the back porch stairs in the faint breeze
I thought hard on all these matters:
Dark are the bruises in the night sky
between the torrents of starry light

UNDER THE BLOODED FLOWERS

this is the skin I wear to bed
every night and when I'm walking
dusty small-town streets
that's the height of my shadow
stretching as far as the picket fence
around the bed of marigolds

do you remember
when the light dropped between us
knife's razor edge
slicing deeply to the bone

blood deeper red than rose petals
falling drop after drop into darkness
all the blue flowers I grew for you
dancing in transient wind

NOTES TO GROWING CABBAGES

What is there to say about a summer
of too much bright light breaking waves
against the white clapboard house
the sun becomes a relentless curse
no water to quench a dusty thirst
save for the small quantity that flows
intermittently from a rusty spigot
tastes remotely tinny on the teeth

In the evening cooler winds prevail
scattered stars like drops of water
gather around the lake of moonlight
a few mythological creatures appear
in the upper reaches of the heavens
tiny white flowers shrivel in the hedge
mule deer come out on the black
circumscribed edge of distance

In their beds the children fall asleep
to coyotes howling on the hill
white chickens scatter in the brush
blanket sky descends on tomato plants
layered cabbages with purple leaves
slumber on a bed of warm earth
a racoon family harvest variegated
ears of old-fashioned ornamental corn

This is the way the world is, sadder
than an old rag doll in a thrift store
or a chipped plate on a garbage pile
I pull the torn quilt up around my face
left all my good ideas unwritten;
how to plant and irrigate a garden
without the silvery sound of water
rushing down the sandy throat

NIGHT LIGHT

Far distant in the northern sky
a red/white light blinks off and on
for hours slowing moving like
a bumblebee across the horizon
This is the slow night passing
without the brilliance of the sun
to interfere with insect chatter
Walking around the block
trying hard to work up enough
nerve to ask about the dead man's
picture under your pillow

Watching the moth circle
the naked porch lightbulb
already nearly insane from the
thin white wires of light
that twist into the metal base
I slam the screen door shut
try and write a few more lines
but the poem leaving silk
on my hands from beautiful
discoloured wings disintegrates

MAGPIE SONG

Circular saws sing a lovelier song
than the black and white whirlwind
building their stick highrise in my shade tree
I go out and poke it down with a long pole
I keep in the garage for that very purpose
You think it's easy, living in Siberia, Saskatchewan
when the grasshoppers decide your garden's
on the menu or the big borers arrive
to dine on Spanish onions

The birds decide to build higher up
in a crotch beyond my reach
While I wobble on the ladder
trying to get the damn bird jumble down
more mosquitoes than I've ever seen
harvest the blood straight from my veins
I may as well send it to the blood bank in a tin cup
No offence, I know there's nothing personal
about the way nature takes charge
but I'm sweating and fuming
wishing I had a big smelly cigar
so I could puff up a cloud of deadly flack

While thinking about the advantages
of using dynamite in the backyard
I notice the air-conditioned neighbours
(afraid to come out of their house
for fear of anaemia)
are watching from their upstairs window
while the birds go round and round
banging their tails in the wind

Although I am ignorant of bird language
I take the shrieking rage as threats of murder
Thinking about all the times I've been driven
out of bed by magpies torturing the dog
I straighten up my bitten ass end
and work vigorously until I knock it out

When the nest came clattering down
around my head and the ladder fell
into the caragana hedge
I lay in a heat daze from the
massive loss of bodily fluids
Now in the blood prick of my skin
the vocabulary of magpie singing
the Antichrist song of war

DINNERS

After
seasons
of trying
the widow
finally
hooked
a fish
trolling
her silver-
ware

just
lipped
by the
pie fork

The bright
red berries
she used
for bait
repeated
in her
smile

when she
caught
herself
blushing
at her
naked-
ness

THE TRICK OF SILVERWARE

sad face tired
from keeping
so many secrets

cannot tell
a lie that will
hide the eyes

behind the door
polishing guilt
until it shines

in the sunlight
like the curve
in a spoon

FELINE

The cat walks gingerly
along the top of the fence
with the struggling mole
clamped in her mouth
I wonder if being nearly blind
made a difference
where the cat waited
all summer listening
for the sound of the
earth moving slightly
just before the rain

Like when God
grabbed the minister
shook her fears away
until the desperate man
dropping the knife
got down on his knees
and begged forgiveness
she said she couldn't
see a thing but felt
the pricking claws
on her throat

STANDING ON THE EDGE OF THE STORM

windowless house, pity every breeze
blowing straight through my face

I hear the groaning weight
of leaves and bending branches

a bird's nest full of fledglings
falls into the unpaved street

the visible nearness of night
pushes daylight into the ground

I pull my collar up around my throat
wait to quench the thirsty dust

A SIMPLE THOUGHT IN DARKNESS

the light has gone away again
slipping over the hedge
hot afternoon breath easing
in the thin disappearing view

mosquitoes hum an indifferent tune
a small nasal whine insulting
the cautious animal's psyche
I slap the back of my neck
a crushed blood bag with legs
sticks to the palm of my hand

whose blood I wonder? some
warm-blooded creature, maybe
my own or an intravenous offering
from a songbird's breast
or a panting pink-bellied dog
lazing with one leg in ecstasy

I search for the silver beetle
crawling among the stars
slowly pushing itself over
the edge of time falling in the night
onto the back of the red planet

ON THE TWENTY-MILE BEND

Strange birds flock in my windshield
Warblers I think, lost in the half light
tumble like drunken sailors across the highway
at this speed there's no telling how many
but I'm thinking at least in the hundreds
In the red morning the ball of sun rises on the prairie
the sharp glint, knife-edge light stabs
the distorted curve of scratched glass

If this is the last moment of my life
in an impossible dream of unreality, I disclaim
any knowledge of beauty and tranquility
My eyes run across restless yellow fields
the road moves on empty and relentless

EVOLUTION IN SUMMER TIME

mottled tree frog
singing inside
a beer bottle

fresh-torn grass
sun touches
brown glass

the child in me
replaced by
tired bones

dragonfly
hesitating
between us

SUMMER STORM CLOUDS

I find myself counting dead bodies
crushed along the highway,
through the insect paste smearing the windshield
South of Regina on Highway 6

Just as I am about to pass
a mallard flying up from a flooded ditch
smashes into the side of a freightliner
Bouncing along the pavement
my daydreams lose it
flying out of my head into the onrushing traffic

Phobias haunt me like the small
furred animals that lay ruined,
nearly unrecognizable, on road allowances
(collar of coyote, back legs of jack rabbit
black and white skunk stripes)
Wide bands of blood and meat
larger beasts that catch under the wheels
are dragged like paint brushes
colouring the asphalt canvas

At night eyes in the darkness
step out into the middle of time
space closes with deadly accuracy

NIGHT GARDEN

Going where
you will in
dark hours

under plunging
green and white
northern lights

think of all
the doomed
pink flowers

violated
by insect
stars

THE LIZARD CALLED LOVE

I was running hot right through the night
down across the Big Muddy
when dawn came up on the screen
meadowlark murder turned the day scarlet
the sweet song of futility rendered
in a dozen prairie back-road dialects
a white plume lined the roof of the sky
I wrote my name in urine in the thirsty dust
about a thunderhead away from Mars

In the end I found you asleep in a nearly
empty one-room shack in an aspen grove
you weren't even a little surprised to see me
as if you knew I'd drive five hundred miles
any night to see your sleepy waking eyes
the speech I rehearsed in the rear-view mirror
sincere as hell over so many rubber-eating revolutions
turned into a dithering pack of awful clichés
even my eyebrows stopped their sincerity routine
before I managed to utter a fragment

I am tongue-tied inarticulate cold-blooded
a complete waste of humanity in disguise
you my tattooed beauty are a lithe snake
in your silk sheets and milky skin
your wide-open pretentious hips an entry into nirvana
Do I go or do I stay you're thinking in your mood
I can read the moth-like patterns of your mind
softly calibrating the mysteries in our DNA
My pride scatters sparks in the flint-tongued silence

WINDOW INTO DARKNESS

Rain drumming on the tin rooftop
dents the sound forming in my mind
Choose my words carefully before committing
them to the scrutiny of your critical gaze
you seem to weigh them on a scale
before you hammer them back into me
a pound or two of galvanized thoughts
penetrate my wooden bones one at a time
whenever you bend one you pull it out
leaving a fresh hole dripping blood
on your precious Persian carpet

It's my fault you have bad aim
like the lightning that comes in the night
I wonder how imagined yellow flowers
are making out in the roadside ditch
invisible in the breath of windy darkness
you see through every situation
as if there is a window cut through
the scrutiny of time and distance
I am a goner under a tin universe
while you stare at the wilderness
waiting for the light to bring you home

THE CHURCH BESIDE THE ROAD

O blessed are the travelers passing
through the night under the storm
dawn shines on wet leaves
eye of the sky reflected in puddles
in the scalped pasture
thick mud under the wheels
throw clumps at the sun

stop at the white church
to roll a cigarette on a thin
Zig Zag paper that sticks to the lip
whitewashed church
small spire, badly patched roof
locked door, windows
boarded up against violators

strange hum of insects
in the gathering heat
I watch them crawl under the crevice
beneath the closed entrance
maybe this is the way God
enters and leaves his house
on the long-forgotten road

in the abandoned country
wind talking to stunted trees
tells a quiet story about love
being taken for granted
like a small scar on the upper lip
a few old tilted grave stones
hide in the tall thin grass

THE SNAKE OF TWO MINDS

Hottest place in the universe in August
Yellow Grass, Saskatchewan

Nothing sadder than the dog
left in a hot car tearing the seats
to pieces before lying down
in terminal convulsions

the Legion doesn't close
for another eight hours

THE HOLE IN GOD'S SHOE

limping on the side of the road
God with a long white beard
wearing filthy rags, pushes
his bicycle along the freeway
He stops to gather beer bottles
pop cans and other treasures
he hoards in plastic bags
tied to his handle bars

yellow dog running behind
chases rabbits, gophers
car bumpers but they go so fast
he can only imagine catching them
with his open mouth, lagging tongue
sometimes he gets so close
the wind knocks him down

old man God with leather skin
and red-rimmed eyes peddles by
hair and beard streaming behind
a blackbird rippling in the sun
dive-bombs his head until
he wobbles into the ditch
riding without hands waving
his arms like a man possessed

CROSSROADS

The grey kitten found
on the edge of the road
with bug-infested ears
torn pad on its front paw
sucks on the end of my pinky
while I stroke its emaciated body
with my other hand

Emitting a noise like a helpless baby
(drowned out by the diesel
gearing down as it passes by)
it gently pricks my wrists
with tiny sharp hooking claws

Too tame to be born wild
abandoned by a heartless coward
afraid to handle death
thrown out like garbage
from a passing car

I wonder, when God looks
in the mirror, if he sees anything
but silver light shining back

THE EYES OF DARKNESS

Sunset broken in the sky like the gut of some strange animal
Spilled on dusty trees spreading out across the horizon
A meal for the gods or Technicolor bruises of consciousness
It all depends on the viewer and the point of view
Painted on a canvas this image might become a total cliché

Whining mosquitoes dance inside the vacuum of my hearing
In no time darkness comes down around my side mirror ears
Smothering my eyes from the rapidly exiting light show
Soon after my focus returns to the unreality of the moment
A few scurrilous stars show themselves in the penetration

Constant wind bathes my face in gentle harmony and direction
I stand in silence feet planted firmly in gritty sand
My mind empties of worry like a bellows pumping air
Until I see your eyes staring in the darkness my lovely
I am no longer a burdened slave fearing your affection

Heat Wave

TWO YEARS WITHOUT RAIN

Red maple bugs swarm into the house
drop onto the dinner table from light fixtures
or lose their grip while crossing the ceiling
Every fall day I kill fifty or a hundred
Impossible to keep dust from the bedding
it covers the furniture like sifted flower
Smoke rising from gravel ribbons
drifts far away into the heartland
Burned out prairie; torched fields, stunted crops
Holes in the sky open to unknown destinations
ticking cherry bomb high above the horizon
jagged cracks in the earth swallow the sun

The thirsty wife went looking for love elsewhere
Blue lagoons in Costa Rica lavishly illustrated
by the customs and quaintness of white birds
In one tiny eco-zone, near a luxury hotel
twenty different variations on the theme of frogs
and no army to shake down the tourists
or Castro figure to dull the experience
This morning a sudden rain drops onto the heat
restoring balance and harmony in tropical paradise
In the glass-bottom boat she has her picture taken
by the same photographer who snapped the pope
shortly after the bullet entered his abdomen

THE WAITING GAME

How do we remember the generations?
A piece of cultivated land, an old fence
a farm house falling in from disuse
on an untraveled roadway
A few hardy perennials
in the dry weedy margins
quaint old-fashioned flowers
city dwellers never grew

Do you think spirits dwell here?
Maybe the ghosts of stillborn babies
or a man's unfinished thought
before he dropped dead packing ice
up the steep back stairs into the kitchen
Some people think he still hangs out
on the edge of the road fifty years later
waiting for his wife to visit
his unmarked grave

Three months after the funeral
she married a seafaring man with
big whiskers, moved to the west coast
Took a job in a funeral parlour
Nobody around here has heard from her
since Ruby got the postcard that read:
Hasn't stopped raining since my arrival
I left him two weeks after we got here

DRY PLACES

for Maury Wrubleski

Abandoned buildings, stripped by the sun
Old bachelors in their dirty underwear
prance around in the heat mirage
Not even one sad farmer left behind
to sit on the rotted-out porch
At night constellations fall through the roof

Crazy water starved landscape
earth cracked into poetry shards
Wind teasing small dust devils
over dead grass and dried out brush
Heat popping caragana pods
in the dusty hedge of yellow flowers

Everything left in a temporary daze
that has lasted nearly a hundred years
Barn door banging in the wind
Stalls long ago vandalized for wood
On the way out a lucky horseshoe
nailed above the empty doorway

Going somewhere else, they said
without really knowing where
Stopping one last time at the graves
it must have hit real hard in the gut
These are the lonely ones who
stay forever in this unloved place

Dancing bones rattle
the wind's dusty throat
They get out of bed in the grave
ghosts for the haunting
The children always want to run ahead
but are afraid of the darkness

HEAT WAVE

Misery loves the company of broken dreams
the way drought slowly ruins a dry-land farmer
as if he were an unwatered plant, wilted,
you might say, like an oily rag
In the extreme heat of the afternoon
near cottonwood trees a rusting car craves
the challenge of a panting dog

Scream of hawk travels through shattered glass
into the faded rooms of an abandoned house
In a trailer across the overgrown yard
a wife and child wait patiently for the prisoner
who is never coming home because
of the blood he is spilling this afternoon

At dawn an agitated bird greets the sun, singing
a foolish song, for its delivery from the void
White dust slowly strangles stunted trees

BLUE WORDS

Sun eats sandy grit
wide-open yellow mouth
on a windy aspen day
a white butterfly defines
blue waterless sky

Time spills into the valley of light
showing darkness the way
the trail winds through brush
thorns cut red cloth to ribbons

Whining mosquitoes hover
inside inner hearing
liquid trickles down a throat
not a drop falls into dusty
river passing underfoot

A dozen stones gather
at the stream crossing
I hop across the top of them
fall in without making a splash

THE FIRE

Everything on earth burning
The crackling trees going up in clouds
of white impenetrable smoke
Ditch grass rips along
the wind in flaming sheets
Clothes on the line smoulder
against the patchy blue sky

The crow on the fence post
already charred and disfigured
with his split tongue cries for pity
but the merciless sun beats down
on his blackened tail feathers
and the curious glass-like eyes
that shine out from his head

On the top of the hill the houses
start to catch fire, hoses trained
on the shingles cannot stop
the heat from grabbing hold
Inside in my bedroom asleep
I can hear voices in the street yelling
but I never wake up in time

The inferno never stops burning
in the unconscious nights
Smoke breathes through my pillow
The bed levitates on a ledge of fire
In the poem written in the dream
I cry out like the black bird
hard glass in my eyes

SAND HILLS

For a while the summer sun flares up
sunspots attack the retina in the eye
White birds, I suspect seagulls,
from the shape of wings against the sky
Silhouettes of lost paper kites
soar in wispy clouds, thin
as an old woman's moustache

In the dry brush insects flick sand
onto the leaves when they spring away
the hot grit sparkles fools gold
hard bodies fly on slivers of light
many colours of green turn yellow
and brown in the thorny hedge
a small spotted skunk
waddles across the sand dune
leaving an unusual imprint

The moon in blue sky half a scythe
By nightfall it is haloed by
purple and orange clouds
the soulful bird calling in the thicket
Telling a story or praying for rain?
I can't decide, you think rightly
he'll stop when the sun goes down
I'm not surprised by the blizzard of stars
or the tiny green frog in the desert

WEATHER VANE

Sparrows tangled in horse hair
build their nest in the crotch
of choke cherry wood
I wander in the fields
looking for good stones
for medicine dreams
Watch the hawk soaring
against the river of air

In a few minutes the sun
drops behind the horizon
bloody sun spreading
in sandy coloured clouds
I walk back beside the garden
smell onions growing
in the black earth
listen to shiny winged
crows flying around
their roost in a frenzy

Every day, a day of wind
but for weeks,
the spring rain holds off
Thunderheads pass by
rumbling in the distance
Every few seconds another
flash of lightning across
the front of the sky
Cock spinning wildly
on the barn roof

By morning only half
an inch of rain in the glass
the dry wind already
licking it up in a swirling
cloud of dust
Damn bird turning
this way and that way
making a thirsty noise
like a rusty gate

WHEN LIGHT FALLS FROM THE SUN

Two hesitant deer disturbed by
an unknown presence stand
with their ears erect before they bolt
Flashing white tails as they plunge
through long grass into the bush line
I stay a while in seclusion

The rustle of time stirred by the wind
catches the light in green waves
and drags it across the field
In the dust a small black beetle
shiny as a drop of motor oil
hurries across coarse stems

YELLOW FLOWER

wind howls over miles
of prairie weather
the voice in the ear turning
loud and miserable into the face
or a gentle whispering reminder
of where you've been
like a boot full of dirt

in the dry bottom a roadway
between gravel crushers
One tall elusive yellow flower
growing twisted and contorted
on a pyramid of crushed rock
wind strokes its ragged head
sun soaking into the sand

NEWS

I proclaim it, waving my arms
dancing in the drops of rain falling
into the smoky dust on the front street
Today the third thunderstorm of the week
finally dropped some moisture
on the buffalo beans and ditch hay

Rich mixture of dust and water
whipped into a coffee-coloured
smear on the truck windshield
Worn out wipers leave
an ethereal yellow haze
etched into the glass

Like looking through the lens
in an old man's eye glasses
I used them to help me read
the fine print in the classified ads
Finished the crossword puzzle
before he got out of bed

WALTZING MAN

Thought he had a partner dancing as he did
in the good weather on the outdoor patio
When I looked closer I realized
he was waltzing solo all summer long
In this town everybody minds their own business
dancing with an invisible partner
is not against any local bylaw

It certainly will get you less notoriety
than talking to yourself in public
I don't mean a full-fledged conversation
just a little slip of the neurology
between the brain and the tongue muscle
and you'll be the talk of coffee row
— the waltzing man's lucky nobody is listening

You said, "Maybe he's advertising for a partner"
I can't argue with a woman about the dance
It just doesn't help to call it intuition
He continues dancing right through Hallowe'en
I wait patiently hoping for a glimpse
of him waltzing around the winter air

SYLLOGISM

Today a raging earache
in the middle of the afternoon
Darius came by three times
looking for Dolly
driving a red Ford pick-up, a front
end loader and the twenty-eight wheeler
that goes to Manitoba.

Lloyd was here, climbing
a major league laundry pile
to read the water meter
in the basement
(outside at forty below
it would freeze like a plastic toy)
Do you think he found the
nuclear chili peppers
in the radiation chamber?

Wild Bill rides in on his three
wheeler for coffee. I sit
quietly across the table
from him thinking:

All women named Ruby
live on back roads
in the country, except
for the one who lives
across the street

GREEN TOMATOES

A few boxes of green tomatoes
ripening between newspaper layers
An old prairie trick to embarrass
tomatoes into blushing

I keep them on the dark porch
in a paper hen's nest
next to the warm kitchen wall
In a few days, what the sun
cannot finish, will turn red

So simple I think, looking out
the bedroom window, at black vines.
What the hell, there's no reason for it,
if chickens can do it, why not?

SHADOW LAND

Look there, a hand in the distance
waves goodbye, waves hello
or some gesture of defiance
at an unlikely trespasser
or the affectionate greeting
of a friendly countryman curious
at who might be passing by

Not close enough to tell
the difference ever moving
further across the rocky plain
seeking the lonely path of isolation
the soul's hammer pounds
time's anvil sheds the sparks
cinders die in quenching dust

Far across the sky cloud shadow
surges over the ripening wheat
until it disappears on black earth
a fallow space in the muddle of time
the cool skin of air touches an eye
measured breath of darkness
waiting on the other side

MEDITATION ON A BIRD'S SKULL

How soon the summer goes awry
blackbirds turning into black clouds
in the clear crisp fall air
flit around the harvest sun
moving in unison, one entity
rises and falls in a modest breeze
flying south for a new season

First frost lightly in the grass
burns fiery against falling leaves
Greater Canada geese fueling up
in grain-spilled fields stagger about
easily mistaken from a distance
for old men wearing black
and grey raincoats leaving the bar
at Bladworth or Craik

I see them along the roadside
taking a leak in the dusty margins
all that grain flowing from the beer
back into the prairie earth
watering the sparse yellow flowers
that lift their ruined heads
into the wind dying slowly forever

"time, distance, light, and space"

RECENT WORKS BY TERRY FENTON

After All
Near Saskatoon, April 30, 2004

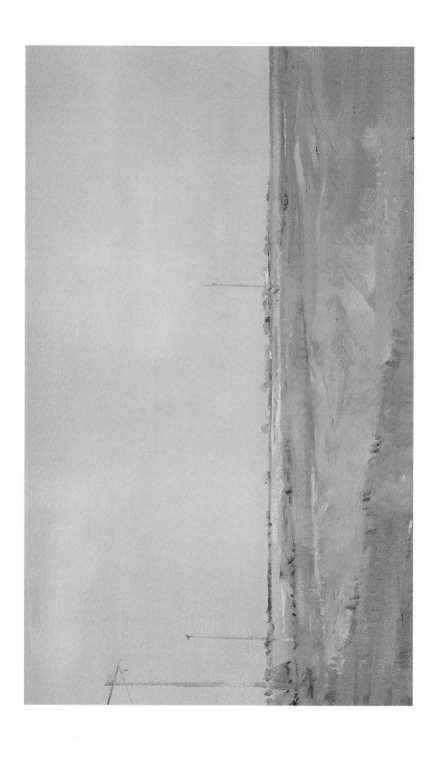

Outskirts
Farm south of Saskatoon, July 1, 2004

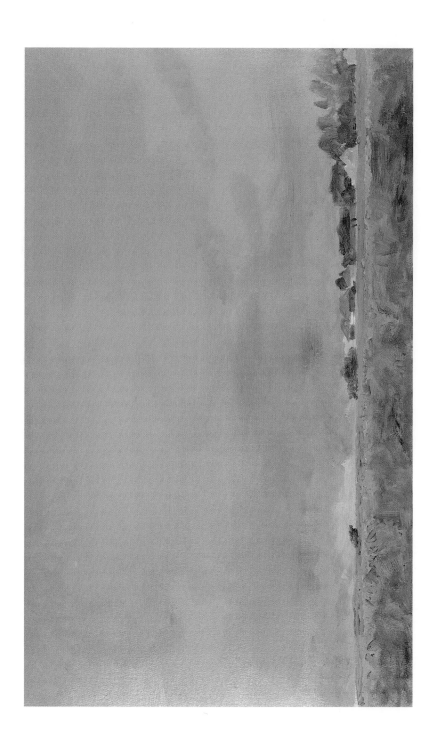

Melt
Loreburn, Saskatchewan, January 6, 2005

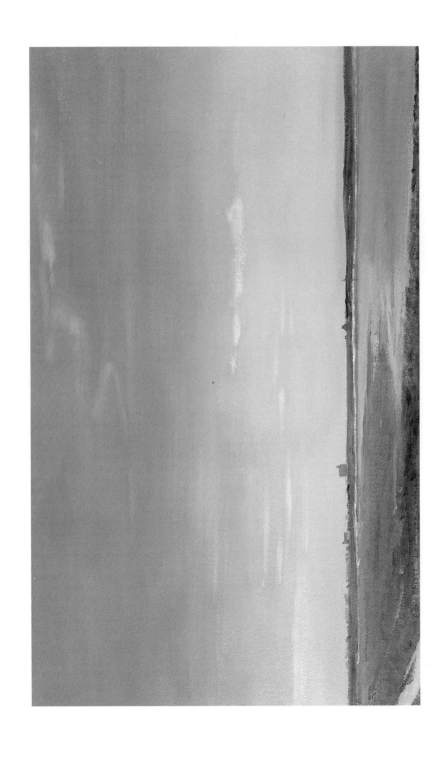

Two Step
Near Davidson, Saskatchewan, February 16, 2005

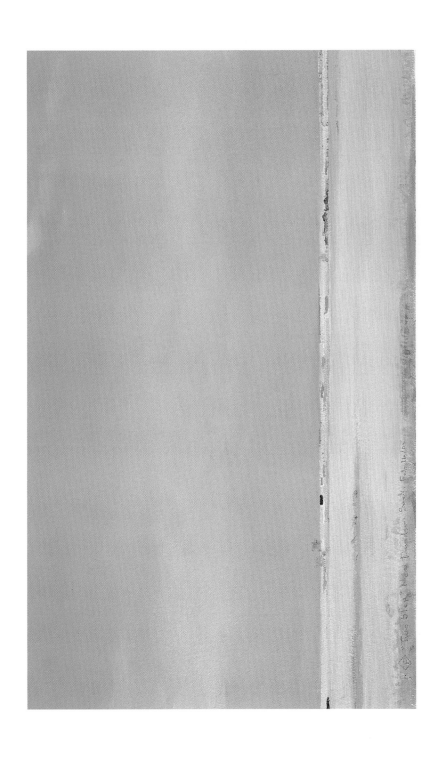

Thirty Below

THE ROAD TO ST. DENIS

White geese
scatter over
combined fields
rice grains
spilled from
a burlap sack

No idea how
the church steeple
holds up
the weight
of the heavens
on its thin spire

Lonely wind
tells nothing
about people
or an empty road
but the sky
can be read
like a book

THE DUGOUT

Nothing here but glazed wind
rubbing off the ice and cow
tracks down the slanted mud
a simple strand of barbed wire
stretches over the deep end
drawn thin as a pencil line
across a half-frozen eye

In early spring boys come
to float wooden planks
and battle pirates on tall ships
sinking them with cow chips
and cabbage-shaped rocks
fired like cannon balls
through the emerging skin
slush turning into ice
now the sun has gone

When they finally realize
only a glimmer of light
peers through the clouds
at the horizon's edge
frost numbs the senses
words and breath come
out in torrents of cold fire
far beyond the fallow field
a yellow kitchen light beckons
silence strikes the clock

WHAT IS KNOWN ABOUT REGINA

It is snowing and raining at the same time
An incredible purple and orange sunset
spreads jelly and peanut butter on the western sky
I stop for gas, step into a river flowing swiftly down Albert Street
If I only had time to burn my lips on a Rocca Jack's cappuccino
but that tiny inkling in the back of my head tells me
don't waste too much time getting the hell out of town

There is no reason to pity anybody who lives here
They all deserve the buffalo death of the white hunter
Pile of bones, pile of government, pile of Indian futility
Louis Riel appearing in the sky speaks to me in tongues
moving his mouth like a Monty Python animated dummy
I see the rope around his neck and the priest's hands
making the sign of the cross above the sandwich clouds

THE MONKEY WALKS SOFTLY ON THE SNOW

All winter I looked in the trees for coconuts
found out they don't grow even slowly in Saskatchewan
there are no plantain plantations down south
or pomegranate trees growing in the sand hills
I went from town to town on the number 11 highway
showing people a picture of the lost monkey

the mechanic in Bethune said, he might, that is might
have seen him, at least him or someone
about his size or shorter maybe by an inch or two
did I ask any of the folks over at the ostrich farm?
the man at the RM office in Lumsden said he
wouldn't hold out much luck that monkey
makes it all the way to Regina but if I was smart
I'd try the bus station located just behind the Hotel Sask
or the Copper Kettle down the street or maybe
go over and check out the bar at the Plains Hotel
never know where you might find a runaway monkey
between you and me they aren't very trustworthy

I got bad advice and knocked on a motel door
the short hairy hyperactive man was not amused
you were expecting maybe until death do you part
from a relationship that began in a pet store
there are a million monkey stories on the great plains
every time I followed a trail it was the wrong monkey

THE POND AS A WHETSTONE

A poplar tree frozen in moonlight
white trunk a gleaming shank of bone
Looking up through chandeliers
among spanners of lunar branches
a myriad of stars swim in the northern sky
Hemisphere of skull dark as a dream
Pieces of light cascade swinging beams
over acres of frost-clasped meadow

The wide silence small as a bee sting
spins away from the earth
Soaring envelope of sail
opened on the winged knife edge
Wind-honed by a round palm of ice
glancing from my face
in the tree-yellowed reflection
My hair catches light like a bush

FAT CRICKET DANCING IN THE FAT

No way to keep it out, the cricket
got into the house when cold wind came
down from the north country
Whenever I dropped my guard
it chirped loudly from another direction
Holding my boot ready to cream it
I snuck around the house until
a long silence set in, thinking maybe
this bug's a ventriloquist

After a few days of futile hunting
I found the silence louder than the chirping
Damn thing seemed more human
than cricket, rubbing its hind legs
across stereophonic sound, whenever
I sat down to read the paper
You figured, try the furnace ducts
and you might have been right, although
all I could find was a brass button
a used band-aid and a world-class dust ball

On the last day in deepest October
with the ashes of Hallowe'en on the floor
something jumped unexpectedly
into the popping hot oil in the wok
on the back of the electric stove
It was the fat cricket dancing in the fat
with a funny expression twinkling
on and off on his antennae-framed face

I fished him out with the wire strainer
perfectly cooked in his steaming
hard-cased body made of black beads
strung together with copper wire
Drained him on a paper towel
the cat came over and touched it
with her nose while I waited for the
extra loud interlude of silence

SILENCE

Whether I breathe or not
walls are quiet

while I lie against
you dreaming

ice builds on the
inside of the window

BY INDI LAKE

Another time waiting
on the old highway
just before darkness
beside the thin blue
blanket that covered
bleak rutted snowfields

Headlights downcast
in the ice fog
isolation of time
passing in the gloom
memory taking over
control of the mind
the way a shadow
haunts its own body

Until the scalding
coffee in the metal
thermos bottle
trickled down
my throat
but then, the car took
so long warming up

MIRACLE

When the village baker's wife turned up
after disappearing for sixteen years
everybody came out of their houses
to welcome her back, even the younger ones
who could not remember her gap-tooth smile
horses on the edge of town celebrated
clattering across the rutted field
chugging out great ribbons of white smoke
and fire from crazy equine eyes

Dressed in a fox coat and high boots
she stepped lively across the snowy threshold
wearing a bonfire smile
nobody had ever seen her with blonde hair
and penciled-in eyebrows
Walter the baker covered in flour
cried at his good fortune
others thought his tears
vindication for a wounded psyche

After suffering his great loss
he was affected by mysterious voices
talking to him in the middle of the day
causing arguments with himself
he wrote elaborate apologies
with his finger in the flour dust
while customers waited patiently
inhaling the aroma from his ovens

Now smiling and giving away bread
he changed the way of combing his thinning hair
bought a new suit and a pair of Italian shoes
when the church bells started to peal on their own
it was declared a revelation until the deafening sound
tolled on all through the night and into the next morning
some thought it was God's way of announcing
the wayward one was back in the baker's bed

UNDERWEAR MAN

The woman put her feet
into the fridge before going to bed
to let her husband know
about a lifetime of winter

An arid man knows he's beaten
when the icy grip invades
blue veins in bony legs
tighten up like chicken tendons

No option left but to die
and leave her sitting pretty
nothing sinful about giving up
he wears longjohns to bed

WINTER KILL

Laughter spooned
from the sugar bowl
onto crunchy cereal
A handful of raisins
scattered on top
make a tasty breakfast
until I put on my glasses
to read the paper
and notice one
raisin has legs

Really a flight
of last season's flies
dropping through
the settling cracks
in ceiling tiles
where they crawled
down the joists
in winter before
they died

BUG DANCE

winter's kill on the threshold
coffee burns the throat raw
last kitchen flies dance window panes

torching tiny feet on grizzled ice
fly muzzles froth like mad dogs
trotting in the silver hedgerow

slapped with one hand
death puts a hole in the silence
smacked glass recovers

light continues vibrating the retina
wallpaper curls around the toilet
the exotic wife sings opera in the tub

WHITE LEGHORNS AT CHRISTMAS

Snow sifting down, shifting by the
angle of the wind. Everything white drifts
low visibility through the grey bush line
Day after day the sameness continues
nothing happens for several weeks
until the fox appears beside the chickens

One by one, they start disappearing overnight
The others become so traumatized they
forget about the thirty-five below temperature
and start laying eggs like slot machines
on the payout dropping loonies into tubs
when they aren't huddled around the light bulb
or being dragged across the yard
in the jaws of the quick smiling red-head

He ends his nightly sessions by putting
his neck in a wire loop meant for assassins
Frozen to death in a snarling mood
he strangled himself trying to escape
In a few moments of cold gluttony
coyotes tear the stiff body apart
while the dogs barking in fury
stay close to the yard lights

The chickens are back to barely
surviving the hoar frost, shaking their
wattles at the thinness of the light bulb
Afraid they might lay an ice cube
they cluster together on the perch
barely able to squeeze an ample dropping

SNOW FILLS IN THE LANDSCAPE

Visibility has traveled down the highway
This is a good reason to stop in the next town
and kill a few hours reading a book
in the local cafe while the storm blows by
Two hours later the Mounties have decided
to close the highway to Moose Jaw
Outside blue and yellow gas station lights
sizzle in the slanted gloom
Snow dances in the air in the frantic
moth-like trance of soft wings

I hold out my glove, catch a handful
and put it against my lips to taste
the bitterness of winter passage
My footsteps across the parking lot
fill in as fast as I walk away
snowflakes melting in my mouth
leave no trace here or there
Everything pure white and fragile
made of wispy hair and brittle glass bones
winter's smoky fire burns around my body

THIRTY BELOW

In the stainless steel night
ice glitters in the headlights
the semi on the inside lane
slams into a whitetail buck
breaking its neck and back
big brown eyes die slowly
in a simple act of departure
Gradually unfocusing,
they glaze over

Animation of the spirit
leaving for unknown parts

Slipping a knife into the belly
the insides, turning into soup
drain from the body cavity
pooling around our feet
Trying to salvage something
we take off the hind quarters
load them in the trunk
Pour scalding coffee
from the metal thermos bottle
onto bare hands
thaw out stiff fingers
wash away bloody stains

Wiping the knife blade against
the hard snow crust
edging the highway

PRAIRIE HAIKU

hole in the lake ice
a round grey shape of water
stares at the red sky

WINTER MOON

Think about the small gaping fish
all winter under four feet of ice
they aren't very hungry for rubber
worms or shiny imitations
I go home without any luck

you're waiting patiently for me
in the darkness under the feathers
in the frozen night after scraping ice
from the bathroom mirror
I find my way to bed with a candle

tonight the moon stares at me
through the bedroom window
from an icy hole in the clouds
I try not to get careless and grab
the glittering moonlight bait

IMPRACTICAL DAYS OF OPEN HORIZON

I stayed here in the window most of the winter
looking at time passing oblivious to the grey streaked sky
Memories etched in blue pen onto the white paper field
left a trail of capital letters and bruises on the margins
around the edges of the lake of the brain

Let us understand the stubbornness of frozen pipes
the mysterious disappearance of the yellow cat
the half-starved dog with the broken tail
picked up by Hutterites on the highway
I fed him freezer-burned food in the basement

The odd rookie salesman who came out here
in the wilderness and knocked on our door
on the bleakest night of forty below zero
stamping his frozen feet in the hallway
begged us to let him vacuum the living room

Look around we don't do housework
I motion at the cob webs dangling in his face
Worse than that his car wouldn't start
and stayed all winter under a mountain of snow
until the town hauled it away for scrap

LAST EXIT TO ASSINIBOIA

These are the long-haul nights
when I'm thinking about another way
to make a living I'm no good at
Radio waves bounce off the moon
and come back translated into static gibberish
— the damn radio's never been any good
since a glass of Coke spilled into the speaker
In another hour I'll be passing through Regina
not even halfway home the gas gauge travels
down into my pocket like a hungry animal
Every sound grates in my mind,
the sick transmission, the hot engine
that wants to rest in the junk yard

Traveling down the familiar highway
I greet the frozen moon in January
Canadian flag at the Shell station
stiffer than a plank from the dead
weight of wind whipping snowy fields
the car, heated up, about to boil over
it's nearly forty below zero outside
inside there's a danger light on the dash

Winter only a temporary setback
like the luck that comes with metal fatigue
tired bones stand on tired feet
perfectly good tires that always stay hard
go down in the dullest places
when the fluid runs over the radiator
there's nothing left to do but freeze
or sleep in the cinder-block motel

In the morning I open the curtain
transparent light catches between
fingers scratching a message in ice
on the thin shield of window glass
the end of the line going nowhere
semi trucks idled all night long
a tin sign banging the memory of time
red sun spreads on snowy fields

ADVICE TO A YOUNG DOG

Pitying the sound of the neighbour's dog
whining on the front stairs at forty below
I call him over to our house and feed him
all the left-over roast beef from dinner
So grateful, he licks the palm of my hand
Afterward, he curls up under the kitchen table
and falls asleep muttering in dog language
I wonder what's he dreaming about?
Maybe, about putting a cat up the maple tree
the smell of dog urine in the grass
or the decomposing chicken carcass
dragged across the back garden

In the summer I watch him watching
magpies from the corner of his eye
until they land beside his food dish
Suddenly he rushes at them barking,
shaking his floppy ears, and the sloppy
strings of drool that fly off his jaws
It's not about catching them or the kill
When they fly off in raucous debate
he sits in the shade lolling his tongue,
licking his mouth's red wound
before he lies down panting at the heat
Sad eyes full of blood

FOUR MEDITATIONS ON LA LOCHE

1.

god's red line of sun-
rise on the horizon
fish eggs and lard
spread on French toast

2.

snowmobile out
back screams
chain saw murder

3.

the hoarse raven
gutting a rabbit
would gladly
trade his eyeballs
for two aspirins

4.

six foot high
snow banks illustrated
by small tributaries
of dog urine

BEAR ON THE SOFA

Another half-smoked cigarette, another bad cup
of coffee, another pot of potatoes, another sleepless dawn
He stayed up all night with the girl who slashes her wrists,
sang her the same three songs ten times each
The music stopped when enough guitar strings broke

By morning like old times, they're back in love,
and he's already wondering out loud
if he'll get to hump her sister again next summer
in the mountains when they take that long car
ride to Oregon and Northern California

Waited him out the night he went on a bender
Dropped the latch, figured he could forage in the snow
Didn't take him more than an hour to find a warm bed
He was back the next morning to borrow eggs and bacon
Said he'd come back later and pick up his guitar

She waited for him in the luxury car on the corner
Wants him to spend the winter with her in Kelowna
If he promises to beat her up when they have sex
He says he'll go if she buys him a good pool table
and lets him have his way with other women

If you leave him sleeping too long on the sofa,
when the bear scat and overflowing ashtrays
finally get to you and the stupid phone conversations
the only effective way to eliminate the problem:
sending him home to his wife

ELK TEETH

In the winter of big snow
the brothers-in-law made a deal

a tobacco can full of elk teeth
disappeared into a mysterious void
blue night rushed in galloping
on a big rangy stud horse dream
no choice but to lose himself
in the grass widow's embrace
a hand quicker than the mind
snatched the good medicine
shared between them
while he was occupied
with temporary lust
brotherhood went out
like a spent cigarette butt
in the frozen rope wind

stiff in the morning blanket
I smell it in the fire
white knuckles stir the coffee
thin board walls, forty below
the pot-bellied stove crackles and sings
rock candy ice glazes window glass
snow in the field blue as bruises
the fat is sizzling in the pan
a pearl-handled nickel-plated gift
appears tucked into the waistband
in a pair of loud boxer shorts

you must not turn your back
or act as if you have something to fear
while you feel for your knife
breathing as quietly as a snake
through your hair raising skin
tasting the complexity of blood
with your flickering forked tongue
you silently calibrate the distance
you must travel to slash his throat

the old black Oldsmobile warms
up in the yard behind the shack
no time like the present to be gone
or the woman you have known
all your life will have to bury you
quickly the departing ghost leaves
an empty sheet a broken radio
a spent candle stub droops
in a tin can like a limp penis

on the scarred wooden table
sputtering light spits defiance
last-second reprieve from silent death
or a spasm from the darkness
perhaps an act of untold treachery
witnessed in the shadowy room

coyote way out in the distance
waits for something to happen

WOLF

This rock reminds me of the heavenly
place in the dream last night
drove through a hundred miles of bush
stopped at an enormous rock left
on a corner of the field, by a glacier or
something God threw down to break the variation

Further west, cloth in a tree
turned my face, walked another direction
in time across the big flat country
away from the spiritual place
red willows growing in the sand
left tobacco for the little people

An owl sat staring from a human face
trapped in another existence
until the pink and grey sky traveling by
turned him back into an owl
on the back road to Big River the white wolf
showed himself running across the snow

Headlights against black trees, night
falls on thin flakes of light snow
catching the air like sparks from a flint
town lights show on the grid road
the last ten miles on an empty gas tank
smell of sweetgrass in winter

Sound of Time

IF YOU DARE BREAK THIS SILENCE

Look through the long telescope at the distance
the ancestors are marching forth on the horizon
white shrouds and glorious flags tear at the wind
small children run in packs at the front
old stooped ones bent like pins come behind
this is the march of the dead saluting life

below unmade cloud beds in the sky
feet lift up the grass in a shower of dust
the plume of smoke drifts across the valley
the sign of fire from a pile of dry bones
curious white birds fall from air currents
into the abyss of nothingness without time

CHOKE CHERRIES

Black fruit, shriveled leaves
White from gravel dust
Blue and red cloth offerings
Solitude of a holy place
Branches for arrow shafts

Wandered looking at coloured stones
Among cactus squatting in the sand
Picked up a deer skull pierced
By sharp grass, sun ticking like
A forgotten element on a stove

Simple things easily located in time
A long thin distorted shadow
Spirits in the choke cherry woods
Black juice staining the sky
Welts from bending branches

ANCIENTS

Listen stranger, where you wander
among stones resting in buffalo grass
eagle soars above the edge of the world
this afternoon on the burnt sidehill
in a downpour the stone's smooth tongue
in the wide open mouth of water glistens
at grey mountains in the painted sky

Listen to the silence, staring in your face
shriveled up eyes of god in the scrub
ancient ones squat in the dust
under choke cherry bushes telling
a silent story about the power of rock
when full moon light fills the coulee
sun-warmed stone touches stars

GOPHER DAYS

the cranky badger
tears apart honey-coloured
Richardson's ground squirrels
after an orgy of digging
he simulates comic sex
on short piano legs
humping sand thirty feet
rushing here and there
in short frenetic bursts
excavating a sloped field
like a military engineer
resting in the late afternoon
on the weedy fringe
beside a bombed-out crater

he has a short fuse
when the dip stick shows
empty in his hunger tank
he becomes warrior attacker
collapsing tunnels
filling in escape routes
firing wobbly gopher
footballs into the air
snapping them down
before they hit the ground
licking the bloody fur
on a peevish face
wiping his hind quarters
on the spring grass

HAWK SOARS ABOVE

All afternoon a hawk rode along in the air currents
above the storyteller's rambling shack on the rez
his white girlfriend fretting in the back bedroom
tightens the loop of fine wire around the armour plated beetle
pulling it up short before it can reach the open window
by now he's more than half coming on to the Japanese tourist
trying to make a big impression to promote a ticket to Tokyo

His wife and two young sons wait at his mother's place
he averts his face when he drives past
he's taking the Japanese woman to the medicine hills
she's entranced by the stories about the little people
parked on the back road to Little Pine
their coupling is interrupted in the early hours
by a moose looking in the side window

He gets out and offers a handful of loose tobacco
something for the ancestor who came to watch
the opening into the spirit world reawakens passion
the love potion, the medicine in the back of his throat
the embrace of his tree-limb arms, his wooden member
the grunting voice begging her deeper desires

DOG TAIL

In memory of Smith Atimoyoo

Smith, when you died
birds stopped singing
for a while, water ran
backwards up the creek
the crazy man cut his flesh
on a blade of grass
the storyteller went home
to the medicine woman
Wind blew in buffalo clouds
Desperate men
traveled from afar
and the hobbled old women
who sang the young girl
songs, decades ago, came
home to see you off

At Manito Lake
dappled Indian ponies
vanished in clouds
on the blue horizon
Every place at Little Pine,
eagle shadows fell in the sky
Stones whispered gone
into the muffled wind
ripping at canvas tipi flaps
Stoic elders looking
through curious bird eyes
got up and hopped
around like big ravens
the white woman
with all the pain
found her way to God

Smith, on the day
the badger took Gerald's
advice about risking
a bullet in the head
and decided to walk
away and live, you said

Life begins again
at the end of the journey
under summer clouds
where the river
in the wilderness
turns on the prairie
children play
in the berry bushes

MORNING COMES A DAY LATER

for Gerald Gaddie

In this the impossible season of passing moods
I make the best I can of the prairie winter
waiting patiently for the long days of summer
Smith, the ancient one turned our questions
into silent meditations that lasted for days
Power of his prayer travelling through the circle
the grace of God in the blessed lightness of his spirit
We carried his broken body home to his wife
The discriminating mind makes hard choices
Usually tells us more than we need to know
Went down the bloody road laughing harder
than torrential rain ripping into the dust
Windshield wipers going crazy for nothing

Back to writing all night and sleeping
between the days. Lost track of the calendar
When I answer the door the morning sun
greets a long lost friend dropping by
The voice in my head speaks to me in mime
I graciously decline the invitation to travel west
Night left a cold cup of black coffee
on the table to remind me of my obligations
I drink it down bitterly without complaint
Nothing left hiding in the shadow of doubt
This is the end of time standing still.
I bang the wall with the palm of my hand
magically the second hand starts sweeping

THE PRESENCE

In memory of Anne Szumigalski

"When I go if you bake me a plain cake
and light a candle on Hallowe'en
I will try my best to come and visit,"
she laughed between mouthfuls of food
at the Laotian restaurant on 33rd
She'd be in hospital a day or two for the operation
"Surely you know this isn't my first time.
We mustn't be afraid of life or death.
They're opposites of the same experience.
Mr. Blake will tell you all about it!"

Snake plants on the window sills
plastic table cloths, a lazy ceiling fan swirls
therapeutically in the background
Junkie-thin scar-faced young men
plastic Asian babes in Barbie doll clothes
with brightly coloured cell phones
Limes, lemon grass, green chilis
float in the soup of the day
Spicy drama of the season played out
in April on Ukrainian streets
Drove over blotchy snow patches
dropped her off in Connaught Place
Decided to get together again in early
summer when the gardens are glorious

She abandoned her body on the operating table
Went on her last journey into the vivid
darkness in the valley of metaphysics
The gods argued among themselves
like children about which afterworld
Finally, they sent her to be with Mr. Blake
Within seconds they were discussing
nonexistence or the absence of being

Heat turns the sun into a ball of madness
the unattended garden stopped growing
The strange orange cat with one good eye
killed the exotic bird of poetry in the thicket
Left an offering on the back door step
All of her she left behind.

Well pilgrim, which road were you traveling down
not sure, only know it was made of gravel
the Devil on his day off picked me up hitchhiking
somewhere near Cranberry Flats
In the prairie sky white birds rode the troughs
until gusts whipped them off like pieces of rag

Slow motion thoughts ticking down
the credits in the movie of my own death
fence posts snap and the wire zings back
against the sound of ripping metal
roll over in a ditch full of tiger lilies
brilliant orange flowers float in the light

Make a halo around the image of the sun
melodic bird songs in the background
hold their electric notes until the static wipes
them out and the next master of song cuts loose
This was the end of time, you might say
the steady green hum of scrubby bush

THE FEATHERED LURE

Death comes upon us like a curious fox
discovering nestlings in a field
no defence against sharp teeth
efficiently dispatching the innocent
while the bird mother flies around

bumping the ground trying to draw
off the hungry villain busy chomping
down on her gawky fledgling children
eyes follow hesitant flight calibrating
distance between devotion and bravery

yet, when the mayhem's done
broken nest strewn across the gorse
scraps of wind rattling the weeds
the bird has flown to another place
memory's gradually erased by

roaring stars and muffled cries
the sudden cough of some betrayed
creature crashing through the deep
the startled bird flies before the fleet
light of dawn uncovers the grass

If you love the sound of time
moving around the clock face
you will imagine yourself
reposing in a white shroud
waiting for the fire or rattled
earth thrown into the hole
white roots reach down
from crumbling walls

a mouse runs out from
beneath a headstone
where, in a nest, pink
sightless babies wait
for her imminent return
small glimmers of milk
a dozen pinpricks on her
loosened belly flap

I tell you a few seeds
make a big difference
the second hand
planted within the hour
moving always moving
in the same direction
as the morning sun

out she comes again
sniffs at the blue sky
climbing the forest
of bending grass stems

THE MEMBERSHIP OF THE OPEN ROAD

This preacher is shouting into the night
from his tower in Babylon, Alberta
Disembodied voices harmonize in background static
— Maybe Angels on their way home from choir practice
or Diana Ross look-alikes trapped in the radio

He is working up to denouncing the Devil
and the sexual deviants who might be moving
this very night into your neighborhood
They want the seventy ounce steak of your soul
done medium rare on a bed of radioactive mushrooms
and little white cocktail onions

Tonight they are lurking in his psyche
Dappled shadows in the brainy underwater forest
Ribbon of bull rushes caressed by ghostly wings
Mottled Northern Pike follow a rattling lure
jerked and stripteased across the surface of the moon
Cannibal spirits slash at the preacher's tongue

"Friends, God's work is not a cheap proposition
the pamphlets, tapes and CDs are expensive to produce
You, dear listener, in the radio audience
Without you we have no way to exist
Think of it, ten million metric tons of malt barley
standing in lush prairie fields
pounded down the gullet of a nation of swill
swallowing hockey worshiping heathens

If you don't send money who will slam
the door on Satan's unquenched thirst
Why his sexual organs are on fire right now
in some junkie-hell-hole-paradise in downtown everywhere
Air time brought to you by Biblical Books Incorporated
the Christian Cowboy's Temperance Fellowship
and the Holy Grain Bread Company

It's not that easy being human
The path, so difficult to wander in temptation and desire
Only Godless fools think they can traipse
through the minefields of the social jungle
Like the carnal lovers of flesh who rip the family apart
and value it less than a worthless piece of cloth
torn from a shameless harlot's crotch

Pray friends for the simple ones in the Shepherd's flock
those who have been touched by the mark of the beast
Who among us will eat cake and spinach pie in the afterlife?
I will pause now for a word from our sponsors:
Only $79.99, a limited supply of the Pentecostal Barbie
Write in for the authentic recipe from the Last Supper"

Nearly hit a mule deer, bouncing like Lazarus in the headlights
Staggering words and notes struggle through sandblasted static
Trees of lightning, mystical branches of pure light
grow on the horizon, like Joshua trees
embroidered on the satin lining of the heavenly cloak
Hammers of thunder pound the anvil sky

Every highway in the universe has a voice in the night
Dislocated conversations or bitter words
from the lovelorn and the war torn
drifting in and out of time and distance
in the languages of the Philippines or China
or the South American Portuguese speaking revivalists
Even one preaching in Esperanto from Singapore

A stronger country western signal reduces the fading voice
Declaring, "death for murder is a fair price"
Flames in the oil fields, fiery tongues on ultra black vistas
flicker on the bellies of passing clouds
The voice distorted by a hissing neon sound

"Do you love yourself enough to truly love your saviour?
Think of the Devil and his friend Svend Robinson
Sing heartily ye lambs around Jezuz
Ours is righteousness and freedom from fear
from the glory holes of Hades and the fiery boat trip
down the river of gasoline's rag-stuffed throat"

The small blast furnace in the bigot's heart
turns the metal traces in his brain white hot
His fading voice blows up like an old-fashioned radio tube
Buckets of spit spill on a red-hot stove
spatter into the night of gray and pink syrupy clouds

I open the car window and let in the night wind
By Vegreville the blood orange glow of dawn
etches and illuminates the edges of landscape
Wispy mist, thin as cigarette smoke, rises on scattered potholes

A few departing geese go by dragging black wings
Town staring at the cosmos like the pattern in a god's eye
His face resting against a board fence in a pumpkin patch
in a garden on the back road into town

Pale emerging light touches shades of green and brown
One iridescent blue field among the yellow
A chained dog howls at the coyote in the graveyard

BOOT HILL

Robert's in the cemetery cutting back lilac hedges
weed-eating around the grave markers,
including those of his mother and his child,
or he's gluing broken headstones or hauling water

I'm somewhere on the side hill,
if you look you'll find me,
listed as a minor poet from Kokomo

I'm all of that, and a small town comic
available for metaphysical travel
when I'm not lodged here in the winter
proof-reading frozen monuments

Stayed too long and the flat land got me
Now, I'm two brief lines of Times Roman
type on imitation Italian marble

Every so often, a passing duck quacks
that's about it for excitement,
except when they dig a new hole

The afternoon sun nearly unbearable,
tall grass down, but for the trimming
Robert sits drinking beer in the modest shade
Nobody worries about the plastic flowers

CHARLOTTE HAWES

Born in Vancouver in 1948, Allan Safarik has published a prodigious amount of poetry in journals and anthologies and more than a dozen collections, including *Okira* (1975), *The Naked Machine Rides On* (1980), *God Loves Us Like Earthworms Love Wood* (1983), *Advertisements for Paradise* (1986), *On the Way to Ethiopia* (1991), *All Night Highway* (1997), *How I Know the Sky Is a River* (1999), *Bird Writer's Handbook* (2003), and *Blood of Angels* (2004). He edited the anthology *Vancouver Poetry* (1986), and was a winner of the 2003 John V. Hicks Manuscript Award for Literary Non-Fiction for his collection of essays, *Notes from the Outside*. Safarik teaches at St. Peter's College, Muenster, and lives in Dundurn, Saskatchewan.

SHEILA FENTON

Terry Fenton is the former director of the Edmonton Art Gallery and the Mendel Art Gallery in Saskatoon. He now paints full time, and his landscapes and still lifes can be found in national and international collections. He has written extensively on Canadian and international artists, and is a frequent guest critic at artists' workshops and seminars. His biography of the influential prairie artist Reta Summers Cowley is forthcoming from the University of Calgary Press in the fall of 2005. Fenton travels widely in Canada, the United States, and England. He lives in Saskatoon.